I Wish There Was Something That I Could Quit

I WISH THERE WAS SOMETHING THAT I COULD QUIT

AARON COMETBUS

LAST GASP

Published and distributed by
Last Gasp of San Francisco
777 Florida Street
San Francisco, CA 94110
www.lastgasp.com

ISBN 0-86719-650-5

First Edition

Printed in China

One

LAURA HID BEHIND THE PALM TREE with a huge stockpile of bricks. When the engine of the armament train had passed, she took aim and threw with all her might, threw with all her anger, threw over and over, so hard that it hurt her arm. Smash went the windshield of the camouflage Humvee. Crash went the headlights of the helicopter. As for the tanks, maybe the bricks did nothing but scratch the paint. Still, it would be a message to the troops who unloaded the transport back at the base. Even in your own country, even before you deploy your murderous weapons, people are going to do all they can to prevent you from using them. Even if it's futile to fight tanks with rocks, even if it's foolish for one person to fight against an army, still people are going to fight. Still, you have to fight. But meanwhile, there were headlights on the other side of the moving train, a car waiting for the tracks to clear, and Laura could hear voices yelling, witnesses to her act. That was bad luck, this late at night. What was worse, it was too easy for the bricks to ricochet or miss, passing all the way over the train, and that she couldn't risk.

Laura ran the opposite way from home, just in case anyone on her side of the tracks was watching. Then she doubled back around the block, dove into her door, and killed all the lights. She hid in a corner with a tiny candle, ears cocked, trying to catch her breath.

Coming home, I could see the glow through Laura's window, so I knocked on her back door. And knocked. And knocked. Finally, I just opened the door and let myself in. It was always unlocked.

I took a can from the recycle and punched a few holes with a safety pin, then retrieved some weed from her secret stash. I put on the Carole King record.

Laura was about to slip out the window and over the back fence, but couldn't help peeking out her bedroom door first.

"Oh," she said. "It's you. Well, that's a relief." She took off her shoes and put on a shirt. "Hey, wait! How did you know where my stash was?"

Why are friends always surprised when they guess each other's moves? It's second nature. I pointed. "Let me see your hands."

"What are you, a cop?"

"Basically. Or worse. Your hands, please."

They were all cut up. Band-aids I knew she would never accept, so I just held them a moment, pressing softly. "Sing with me," I said.

We sang together with the saddest song on the record then both sighed. "When do you think you'll get over her?" Laura asked.

"Me? Oh, geez. Never."

"Isn't there some sort of expiration date? Or, you know, a statute of limitations?"

"It's a life sentence."

"Oh, Aaron," she said, rubbing my shoulder. "At least pass the can. I can't wait that long."

Two

LAURA'S HOUSE WAS WHEATPASTED wall to wall with old punk fliers and dumpstered photos, all wrinkled and water-stained due to the sieve-like roof, which, at this point, was merely decoration. Instead of sheets and curtains, protest banners from previous wars covered the windows and Laura's single mattress, their urgent demands sadly still applicable and yet to be met. It was a tiny place, but filled with a warehouse worth of little, beautiful, curious things that might have been either keepsakes or garbage. Even the contents of the fridge were a mystery, since *someone* had spraypainted all the bottles and jars dayglo colors, leaving the labels illegible. And the bathroom was filled with graffiti more plentiful and colorful than the raunchiest of rest stops. One suspected that the house's lone resident was responsible for most of it, amusing herself with various pen names.

A general air of disrepair and decomposition shared the house with a thin layer of dust and grime. In short, it felt like a home. Lived in. Loved in. Cozy.

Once upon a time, Laura had shared the place with her girlfriend. But that time, and that girlfriend, had long since passed. Now we had a rule. Neither Laura's old girlfriend nor mine could be mentioned by name. Yet, unnamed, their

presence, or absence, still loomed large over our lives.

You see, the same thing had happened to me. The girl-friend, I mean. But I didn't like to talk about it. The point was, Laura and I were together now, and both in recovery. Two divorcees leaning on each other for support. Two old ladies arm in arm for a walk in the park. Our relationship was natural but not easy to define. Companions? Compatriots? Partners in crime? It was convenient that our lives had picked the same time to fall apart.

Laura still lived in the house she'd always had. Behind the place, in a van which had once been the touring machine of Laura's old band but was now a rusting heap of garbage in the corner of her yard, I'd made my home. The Econoline which had previously collected parking tickets and unwanted, annoying roadies now took on my ever-growing collection of old books and stray cats. One bad smell in exchange for another.

Anyway, neighbors. That's what we were.

She called out the back door, "Don't forget to feed the kids." That meant the cats. Our cats, previously known as mine. Whom I had never yet forgotten to feed. Hmph.

Three

OUR WORLD WAS A SMALL ONE. Once Laura and I had criss-crossed across the country with crazy impatience. Now, except for rare occasions, neither of us even left our little neighborhood.

There was everything you could need. A supermarket and library on our side of the tracks, and on the other, a post office, record store, and bar. All within one square mile, all within easy reach. Unless a train came, at least. It was a lucky place for Laura to have broken down and for me to have run out of gas.

Our world was small in terms of people, too. Laura and I had many old friends, but over the years most of them had fallen out of touch, wrapped up in their small worlds the same way we were. Extraneous people and things had just seemed to fall by the wayside, which felt good, once you got used to it. That left you more time for what was important and close at hand. You became more aware of what each person around you was going through. You learned to share their joys and sorrows instead of always racing out to rack up your own. Share their problems, too.

The sky was beginning to get light around the edges. A pair of cardinals flew up and perched on the birdfeeder I'd built in the backyard. Just a few feet away, two of my

7

cats lay in the grass, curious but harmless. The birds looked at the cats and the cats looked back. No problem there. I crouched in between, setting out food for both parties before going to sleep. One peaceful little corner of the earth. Perfect. I counted my blessings.

Number one, I'm in good health. Number two, I'm not in prison. That's lucky. Number three, I'm home, not waking up in a strange country or on a stranger's floor. That's fine when you're in the mood, but I'm not. Four, I'm single, so I can grow my hair long and not bathe. I can write on myself and talk to myself. I can keep odd hours and a bad attitude. I don't have to jump through hoops to be reasonable or understanding or to explain my actions. I don't have to make anybody happy. Not that I ever had much luck at that with her, anyway. Not as if she minded any of those things I mentioned, either. No, she liked them.

So what went wrong?

A small world, sometimes it got a little too small. But that's how it goes. The extraneous things and people just fall by the wayside. And some of the best things, and best people, too.

Four

In the morning, Laura rattled my cage.

"Good morning, beautiful," she cooed.

"Morning, my ass. The sun's still out. What kind of a morning is that?" I gave her my "angry morning" face, also known as the John-Brannon-from-Negative-Approach face, and took a mock swing. She ducked.

I grumbled and groaned putting on my clothes, but secretly I was pleased. I was always glad to wake up and face a new day. Not because I had any hope for it, but because anything would be better than my endless nightmares. Sleep had stopped being a pleasure many years before.

I honked the horn. "Coffee!" I yelled. "Coffee! Coffee! Coffee!"

Laura was reclining in one of my lawn chairs. "Why do you think I woke you up? I'm all out."

"Ah, crap."

The first moments of each day were still a little unsteady. I had to do inventory. Did Laura die? No. Did my family die? Yes. Did the house burn down? No. Did the girl leave? Yes. All in all, the reality was not as bad as the dreams. But, far from perfect. The days of waking up to find that everything bad was just a dream were far behind

me. But that's what coffee was for. It sounds crazy, but the trade-off was almost fair.

I fumbled around the van's built-in cupboards, useful but somehow always the wrong height for humans to reach. The stovetop percolator had been with me for many years. I packed it with Peet's and stepped out the door barefoot. My kitchen was in the shade next to the garden: a Coleman stove attached to an old barbeque grill. Not to be confused with my dining room, an old school desk with a blue tarp awning.

"Aaugh!! Piss! Fuck! Shit! Goddamn fucking suckhole motherfucking stupid ass place to put a..."

Laura didn't laugh, or even need to look. "You gotta move that cactus," she said.

"I know, I know." I hopped on one foot. "But it loves the shade."

"Suit yourself."

The percolator was soon growling too. Ah. I divided the sweet fluid into two cups. A little more for me.

"Selfish little asshole," I muttered. "I will change, I will change, I will change." I intoned it like a mantra between gritted teeth, stomping the ground with my already hurt foot.

Laura was oblivious to my inner struggle. I handed her my cup.

She narrowed her eyes at me. "So, where's your girlfriend?"

"My girlfriend? She's in New York, living with some other guy. It's kind of an old story, actually. I'm surprised you haven't heard it by now."

"No, I mean your *other* girlfriend. Susan."

I looked at her like she was crazy. "You're crazy," I said.

"And getting paid good money for it, too. But I see you walking around together late at night."

"Oh, Laura. Don't be silly. It's not like that."

"So what's it like?"

"I don't know what it's like, but it's not like that. And what about you? Where's *your* girlfriend?"

"Jemuel? He's coming over soon. Anyway, he's more like a baby than a girlfriend. You should have heard him crying last night about Susan, that cunt. She's toying with him the way a cat plays with a dying rat, and he's the only one who can't see it."

"What are you, jealous?" A long shot, but often the truth.

"No, I'm furious. I'm protective. I'm slipping into my mama bear mode."

"Well, you've certainly got the bear part down, with all the crap you've been eating lately."

"Aaron, I'm serious. She's playing him, and it's hard to watch."

"It's hard not to watch. Who hasn't been there? But if he sees it differently maybe it's because he's seeing something we're not."

"Now you're the one who sounds jealous."

I shrugged.

Laura did her Jemuel impression.

"Good things come to those who wait," she said.

We both laughed at that.

Five

Laura's friend Jemuel arrived, on schedule as always. They got dressed up and went out together.

Jogging.

Ha. I watched them take off. They looked like clowns. People just shouldn't ever wear shorts. They invited me to join them, but I politely declined. Sure, it's good to keep in shape. Yeah. But not like that. I preferred long walks on the tracks, brooding. And gardening, that was one hell of a workout. Followed by drinking. Reading. Smoking weed with my cats. Fuck it. Sometimes I'd even go running through the streets late at night just to tire myself out. But that was *running*, not jogging. And it was a solitary ritual.

I sat in the van pretending I was headed down some highway. Pretending I knew how to drive. What if I saw Jemuel on the side of the road, would I keep going? Yup. I put my feet on what I guessed was the gas and floored it. Fuckin' weirdo. He gave me the creeps. Never trust anyone who's been in the military. When he said stuff like, "It's good to be ready, just in case," you could almost hear the copters coming. Or was that just another train?

To hear Jemuel explain it, jogging wasn't some kind of jock thing, but actually an entirely *mental* exercise. It kept the oxygen flowing, the spirits up, brought new blood cells

and new ideas to the brain.

Right. I didn't buy it.

Besides, I knew what they talked about when running around in circles, and it was the same old shit being bandied around at the bar.

Sex.

Whoops! I mean, *relationships*.

I could imagine the conversations they had.

"Susan told me I should walk on all fours and bark like a dog. How's this sound? Woof! Woof!"

Then Laura would say, "I met this great new girl. I think it's really serious this time. M-hm. Her name? Well, I don't know. We haven't actually talked yet. But still, I have a really good feeling about it."

"Be patient," Jemuel would tell her. But why? Wouldn't it be better to be realistic instead? To change course when something didn't work instead of always keeping up false hope? I had. An impulsive crush once in a while, that was one thing. But once a week? As Laura's designated shoulder to cry on, I was sick of seeing her so hopeful and then so hurt. The last thing either of us needed was some dumb hick egging her on. What did Jemuel know about women? Not much, from what I'd heard. Not that I was highly qualified to give advice either. No. Sigh.

The sun was going down a little in the sky, cool enough now to water the plants. The ginger bulbs were just starting to sprout in the garden. Soon it would be time for me to go to work. I'd have to put on shoes. Feh. But at least I could pick up some groceries while I was out.

Just then, I looked up and saw someone in my rear-view mirror. A woman. I hit the brakes. She was smiling, with her thumb stuck out. Laura.

"Goddammit, you scared me!"

"Going my way?"

"Going to work, unfortunately. But you can get in for a couple miles."

She came around and sat shotgun. She kicked her bare legs up on the dash. "Where are all the women in this town?" she asked. "Why don't you go out and find some girls for us?"

I reached for my shoes. "Don't hold your breath."

Six

THE TRAINS PASSED ALL DAY AND ALL NIGHT along the tracks at the end of our block. First the whistle would pierce the air, then the rumble would shake our little lives to the ground. Every conversation was momentarily cut short, every pleasant dream interrupted or taken over by a train-based theme. Yet it was like the weather—you actually got used to it. Except that every time you left to go downtown, you'd get cut off. Every fucking time! You'd get stranded, standing with a line of cars, waiting for up to half an hour while the already long trains inexplicably slowed to a crawl or even stopped cold, stalled except for sudden lurches and jerks which kept all but the bravest from attempting to crawl through between the steel wheels.

Meanwhile, on the downtown side, the post office closed, the laundromat lady locked up the place with your clothes still in the drier, the friends you'd arranged to meet went home, assuming you had flaked. That was the worst.

Laura and I both jumped when we heard the sound.

Shit!!!

I was already out of the van and tearing down the drive-way at top speed.

When I rounded the corner the train was only a few hundred feet away and coming fast. Close enough to see the

conductor's cap.

Better to risk everything than be stuck on the wrong side of the tracks.

I took a flying leap and, clearing the rails, skidded head-first into a chain-link fence. With one hand, I held on for dear life. The other held the shoe I hadn't gotten a chance to put on. Too bad. Sure would've helped on that gravel.

When the train passed just inches away, the conductor's eyes met mine. He looked over in disgust and pulled the air horn long and loud, right in my face.

Seven

LAURA WATCHED FROM THE OTHER SIDE, standing in front of her house.

Just another regular train. Okay.

The military transports, they came so few and far between, with no set schedule she could figure.

Nothing to do but wait, checking every time there was a whistle. Be ready, and be prepared. There were piles of bricks at a few different places, plus a couple cans of paint and some metal pipes on the odd, lucky chance that one of the military transports came to a full stop. It had been known to happen. All that effort would surely pay off. But so far, it hadn't. Not much, anyway. Sometimes a munitions train didn't pass for days. Which was good, but bad too, because munitions trains made Laura happy. Foolish or not, it felt good to connect those bricks with that glass, to physically respond instead of just feeling emotional and helpless. Instead of just feeling disconnected. Plenty of time left over for that. But Laura wondered: What if I've been careless and missed one in my sleep?

There was a bigger plan, of course. She counted off on her fingers.

First, we lure the police downtown with false reports and stall them using the guitar-string-railroad-crossing

trick. Then Jemuel drives the stolen car onto the tracks. Even if that doesn't derail the train, it'll block it at the bridge. Next, we force the conductor and crew off. And then? Blow the fucking thing up!

Nice, right?

But it has to wait—and the longer it does, the more personal differences are bound to come up between the two of us and get in the way.

Well, he can't say, "Laura didn't warn me." I warned him. But he wouldn't listen. Just like today.

Her blood boiled, recalling the conversation.

When I told him I couldn't keep a gun in the house, what did he say?

"Why not?"

Tsch! Why not, indeed!

"Maybe you didn't notice the shelf full of pills?" That's what I wanted to scream.

So what does he do? He laughs. As if it were all one big joke.

Maybe I should have just put a bullet through my head then and there to prove my point. Words just can't compare. They've lost their power. They don't mean anything anymore. It's not like I want a prize, but a warning label is there for a reason. Hello, don't give me a gun, I'm bipolar. Duh!

She went inside, slamming the screen door.

Maybe it's just become too normal these days. It's lost its novelty. Crazy is old hat. Last year's fashion. All the trendsetters have moved on to something new.

It would be easier if I was down all the time, then people would understand. But that's not how it works. It's just the last hour before I go to sleep, I get so sad. I'd do any-

thing to stop that feeling.

Sitting on the floor in her kitchen, she continued the conversation. She explained, she cited facts, she told funny anecdotes and made little jokes. For once she was confident and articulate, even charming, holding forth as if to a large audience. And she got laughter and loving, admiring looks in return. But now it wasn't Jemuel who she was with. Her daydream had changed company while she wasn't looking.

Laura shook the fantasy out of her head. She was embarrassed, as if she'd been speaking aloud. But to who? The kitchen was empty.

Eight

WHEN JEMUEL RODE UP TO the record store, the lights were already off.

Good. No stragglers. He unlocked the door and went in.

What a fucking mess!

There were stacks of records piled everywhere, seemingly at random. How they always managed, in one or two short days, to completely ruin any sense of order he'd brought to the place—it was a mystery. It was truly amazing. This level of carelessness would take serious, concentrated effort.

He walked down the aisles picking half-filled soda cans and food wrappers out of the bins. He rolled a handcart around gathering all the scattered records which would have to be sorted and filed all over again. There were huge indentions in one shelf, human-shaped, as if the staff had sustained a blast of some sort and landed in the Classical section. Jemuel put his hand over his face and groaned. Why? Why me?

Here and there he came across a mountain of dust or a mountain of vinyl, both products of the half-finished, quickly forgotten projects that the people on the day shift always took on and would be expecting praise for. "Did you notice I remembered to sweep the place?" they would ask.

"Did you see I separated the House from the Jungle?"

Of course, they hadn't remembered to actually throw away the dust that they swept up, or *finish* separating two musical sub-genres which, as far as Jemuel was concerned, belonged together in the first place. In the garbage, preferably.

The phone rang. He ran for it. Susan! His face opened up in anticipation, as if he were opening a gift.

Instead, it was another customer call. They always sounded the same. Different voices, strangely distinct, yet far away in sound and tone. A bad connection—he had to yell to be heard. He imagined they all lived in the same house together, these imbeciles who called, even after hours, with their idiotic demands.

"We're closed," Jemuel yelled, casting a weary eye at the clock on the wall. Hours passed here so fast. "We close at six," he explained, almost pleaded, but he knew it was too late. The mistake of picking up the phone had already been made and now he was stuck with it.

"I have just one small question. Do you by any chance have a copy of *Traffic Jam*?"

Jemuel groaned again. Always the song title, never the artist, and they always expected you to know. What was worse, Jemuel *did* know, nearly every time. Could have learned a few languages, that would have been useful. Learned how to build dams and schools. Dig wells. Anything but this. Too late now, though. It's easier to remember than to forget.

"The Artie Shaw version or Duke Ellington?" he asked.

"What's the difference?" the voice on the other end crackled. "Could you hum a few bars?"

Jemuel felt the sudden need for some aspirin. This is

asinine, he thought. This has got to be a crank. Somewhere someone is having a good laugh over this, I hope. But here we go.

"Ba-dum, ba-dum, ba-dum," he sang. Carrying a tune was not one of his talents.

Nine

PART JANITOR, PART MANAGER, that was Jemuel's job. Come in when everyone else was gone and clean up the store, restock the shelves, pay the bills, and do a little bit of the books. Ideal, really. He could choose his own hours, didn't have to take orders, didn't have to wear a uniform. Excellent. Except for one thing: he hated music. Or, rather, he resented it. Was it music itself, or the whole business it had become? Jemuel thought about it for a minute. Both. Then he put on a record.

He sat on his stool humming, sorting a stack of albums that had just come in, all from the Fifties but in incredible condition. Not that the guy's kids even looked at them, or cared. Except about the value, that is. Seems like we lose a little something with every generation. Hardly anything left.

He wiped the records with watered-down alcohol, cleaning them. Out from the center, always out from the center. Little phrases like that, they're like songs, they get stuck in your head. Now does Ella Fitzgerald go in Vocals or Jazz? Does Chuck Berry belong in Rock or Oldies? Labels may be arbitrary but they're also shorthand for ideas. It's interesting to try to figure out just what those ideas are, where everything belongs.

I'm gonna be here all night at this rate, he realized. Haven't even started on the real work. It'll take me until

tomorrow just to finish what the day shift was supposed to do today, much less my own duties. Well, I guess that's the problem, it's not really clear what my own duties are. As a result, I get left with every task no one else wants to do. And blamed for anything somebody else does wrong. But then, I don't really mind. I'm used to it. That's always been my place in the picture. Better to do it all yourself and do it right than have everyone be responsible for their own little part and do it wrong. It sounds bad when you say it that way, but everyone's happier when it's done right.

Same as giving advice. People, they want real advice as much as they want real responsibility: not at all. The only thing to do is smile and pat them on the back. Listen to them, encourage them. People don't want to be understood anyway, they want to be excused. Or forgiven. For their own transgressions or incompetence. In fact, most of the time when people ask for understanding, they're really begging you *not* to see the obvious. *Not* to understand. To misunderstand. To keep believing the lies they're telling themselves. That's what I think.

"You understand why I fucked up this job, right? Son, you understand why I had to hit you, don't you? Please understand, it's for your own protection that we had to put you in restraints."

No. I don't understand. Everyone just wants to put the burden of guilt on your back. And mine is carrying enough already, thanks.

That's what I like about Laura, she never tries to understand. She just accepts things as they are. Or sometimes she even says, Jemuel, you don't understand me at all, and I don't understand you at all. That makes me really happy, hearing that.

Ten

JEMUEL WORKED AT THE RECORD STORE, Susan at the bar.
Laura worked at home. She worked for the government,
being crazy. A full-time job, and the pay wasn't bad. She
didn't laugh when I put it that way, but she didn't cry either
while cashing the checks. It was true that the government
was basically paying her to plot against it. As for my job, it
was a little harder to explain. Civic improvements. I worked
nights.

Laura couldn't go to the bar because she had quit drink-
ing. Sometimes as often as once a week, she quit. Jemuel
couldn't go either since Susan lived in the bar's upstairs
apartment and, not liking to mix business with pleasure,
had forbidden him to visit her at work. It was one of the
many conditions of the complicated relationship probation
he was serving. Or was that parole?

None of these prohibitions, however, applied to me. A
free man I was, unless you count the prison of my own
making. Even that, I was able to escape from long enough
to sneak in the back door of the bar and help Susan close
up the place.

Don't misunderstand. I despised bars and the people
who wasted their lives in them. So did Susan. We had that
in common. While I had a rule against drinking in bars, she

had a rule, for her own reasons, against drinking at all. Instead, she drank coffee, in voluminous quantities. At two in the morning, who else would be putting on a fresh pot? No one I knew. It was nice to come in from a long night of my own work and join Susan for a cup of hot, black courage. Everyone else was asleep or drunk at that hour. Or a cop.

"Hello, loverboy," Susan called out when I walked in. She threw endearments like that around easily, but this one rang true enough to cause a ripple of commotion among the customers. Lined up like pigs at a trough, they turned to look at me and snort. A few leered, drooled, farted, or merely snored, but the consensus was one of disgust and distrust. The secret brotherhood of drinking buddies had been infiltrated by an outsider, and one of the very worst kind. You spend countless hours and dollars trying to chat up some doll, and what happens? In walks some sober asshole to take her home.

I played up the role, to the hilt. And Susan played along.

I sat down at the counter as if I were in my own living room. She put a steaming cup of coffee in front of me and leaned forward, resting on her elbows. I reached up and tapped her cup like a kiss. Then, as those new to the show looked on aghast, I upended the tip jar and began counting the cash. Neat little stacks of bills, nice little piles of coins. I tallied the total like a bookie or banker might, occasionally licking my fingers or snapping a bill for good measure. Who doesn't relish a part played to perfection?

As I put up the empty stools and took out a mop, Susan reached behind the curtain and turned on the brights. The few remaining regulars cowered and shrank in the light. She gently ushered them out one by one with a sweet but insis-

tent lullaby of kind words. And if someone had drank one too many, she called a cab.

Then the doors were locked and the house lights cut, and we just sat there together like two embers in a dying fire.

Eleven

WHAT DOES A BOYFRIEND DO?

He steps on your toes, he gets in the way, he acts like an ass. He gets jealous, he feels entitled—and then? He tells you his problems. Predictable. But as a stand-in, a hired gun, so to speak, I could do the same exact things and it was somehow different. Why, I didn't know. Or want to know. I was enjoying the role.

The boyfriend act did have a purpose. It kept the creeps at bay. They might wink or glare or offer a piece of explicit advice, but they would still clear out. Not that Susan needed the help. She could take care of herself. But it was our ritual, a nice little routine to end the night. A last song and dance to bring down the house.

I unplugged the light over the pool table. Then, in the afterglow, she spoke. "In case you were wondering, everything still sucks."

"The boy?"

"The same. A moron. I don't know what I was thinking."

"Maybe you weren't thinking." I got up and rolled pool cues on the felt. Every one was warped.

"No, I was thinking. That's the problem. I read too much into it. I figured it out instead of just opening my

eyes. I fell for an idea and woke up attached to an idiot. Ugh! He may be an adult but he acts like an eight-year-old. All men are babies."

"Hey!"

"Who knows more about men—me or you?"

I ceded the point. A useless argument.

"Jemuel walks around like he was just born. Like he's going to pick up every little rock and play with it. I have to watch that he doesn't put something in his mouth. I want a man, not a baby. If I wanted a baby, I'd have a baby. Who needs it?"

"A lot of people."

"Well," she said. "Fuck them."

We dragged the trash bags out the back door and threw bottle after bottle into the dumpster one at a time—our encore. The night filled with the sounds of breaking glass. Then the whistle of a train. Thankfully, it had just passed. "Laura," I said, "I gotta go now."

"Susan. I'm Susan, remember?"

"Oh shit, sorry! Me and my stupid mouth."

"I'll walk you home, come on." She took my arm. We went along the tracks.

"Where's the moon? In the old days, there used to be a moon in the sky. It was big and white."

"Don't make fun of me," I told her. "Anyway, it's not the moon I miss, it's the sun."

Twelve

LAURA SAT ON THE PORCH, staring out into space like the Sphinx. Nothing escaped her all-seeing eyes. She watched Susan and I walking arm in arm along the wooden ties. She watched my Mission Impossible-style move of cutting through the neighbor's yard and hopping over the back fence in order to avoid an interrogation. Then she measured time with cigarettes. When she could no longer see light or movement coming from my quarters, she stepped into her own. From the dark shadows of the refrigerator's bottom shelf, she retrieved a bottle of whiskey. Pouring a long shot into her lemonade, she leaned back.

"It's a good thing I live alone," she said aloud. "So no one has to know."

Then to herself, "Except anyone else would be more understanding and forgiving than I am. That's the truth."

"What happened to you?" she said. And then, "Not this again."

I've got to stop arguing with myself, she thought. Talking to yourself is one thing, but carrying on an entire panel discussion? No good. Too much. Keep it simple. Leave it to the experts. One at a time.

What happened to me? How am I supposed to know? Ask someone else. That woman, she used to be so serious,

so purposeful, so outgoing. Now look at her, she's in pieces. Sleeps all day, then at night she gets drunk and throws shit at trains. Quite a life.

Well, I'll tell you what happened. Nothing, that's what. Still the same. Just that now there's no more reassuring feeling that everything will work out with time and get better. No more faith that if we yell loud enough, someone will listen. No more security even that if we just stay quiet and try to live our little lives, they'll even let us. Not on our own terms, at least. As if these were even *close* to my own terms. Taking money from the government, that pretty much admits their claim that I'm crazy. And makes everything I have to say worthless, because who's paying my rent? Right. But what am I gonna do, get a job at the donut shop instead? Well, maybe. Let's not rule out anything at this point.

My old friends? They're even worse than this. Oh yeah, pat on the back. Compared to them, you're *hardly* an alcoholic. And that's the worst part. As long as I'm drinking, I can't blame anyone else for anything. Suddenly, it's *all* my fault. Even my craziness. *I* lack self-control. *I* can't keep a promise to myself.

As if nothing else factors into it, as if nothing can be anyone else's fault. As if nothing caused it in the first place. Everything that happened to me, it was just my choice, right?

It's so typical. People back you into a corner then act like you're in that corner by choice. They blame you and belittle you for being in a corner.

I don't know what I hate more, the world or myself. Flip a coin.

I used to write and play music and create. Now? I sit

around either gossiping or making excuses for myself. I hate the person I've become.

Well, it's not as bad as that. I only hate half the person I've become. Or two thirds. It could be worse. Three fourths.

I was never one of those self-loathing girls, either. But then again, I was never like this. Now there's something to hate.

Thirteen

JEMUEL HELD A HEAVY BOX OF records in his arms. How many dreams did it contain? How many hours of hard work did it represent? It was dizzying to think about. Not only for the musicians involved, but the photographers, artists, recording engineers and countless others behind the scenes. Who could put a price tag on something like that? Thankfully, Jemuel didn't have to. He kicked open the back door and hefted it into the trash.

He stifled a yawn. Every night was long at this job. Especially when you'd already worked all day at home. But Jemuel didn't complain. The pay was bad. The benefits, nonexistent. Still, he would probably stay until the day he died—and that was just fine. Jemuel was anything but ambitious. In a world of people desperately looking for something bigger and better, he alone was happy with what he had and could get. In fact, he felt blessed.

There were those who had expected more from him. Jemuel himself had expected more—but life is full of surprises. Now he was pleased with the way it had all worked out. He'd become a better person. Humbler. Calmer. He'd even gained a sense of humor, whether or not anyone could tell. He smiled now at things that would have once made him furious. And not just on the surface—he smiled inside.

People were always commenting—negatively—on his entry-level job and the fact that he still lived at home. "You're *how* old?" is what they said, but that was what they meant. Yet Jemuel didn't get mad. He didn't resent their naiveté, but neither did he envy it. Innocence was vastly overrated. Just look at the day shift.

"You're lucky you're on your own," one of those snot-nosed brats was always telling him. "Independent, a free spirit—I remember those days. But once someone is counting on you, all that changes. You have to learn what it's like to take care of someone besides yourself. You can't just be selfish."

Learn what it's like? Did that pipsqueak think he was the first person in the world to change a diaper? Probably. But Jemuel had been doing it for years!

Plus, with a baby it just *had* to be easier. After all, a baby isn't ashamed to have someone taking care of them. A baby's not full of adult fears. Like, a baby isn't going to freak out and accuse you of poisoning their food. And when you come home from a long night working to pay off their mortgage, a baby's not going to forget who you are and threaten to call the police.

A solitary tear rolled down Jemuel's cheek.

Lucky? Why do people make these stupid assumptions? I *wish* I had kids. But I have my hands full enough right now as it is.

With kids, it would be wonderful. You could watch them develop and grow and become someone. Instead of just die.

He checked himself. Can't let myself get bitter like this.

With someone older, you have to second guess yourself all the time. Do I listen to her, or is she delusional again? Is she actually lying to me? It *is* her life, after all. These are her

decisions. And yet, *I'm* the one who she entrusted to take care of her and make the decisions.

It's hard. But everyone thinks they have it hard. Compared to so many people who really have a hard life, mine is a picnic. I'm so lucky. And helping grandmother has taught me a lot. I couldn't ask for a better way to learn.

There's only one thing I could ask for. One thing I wish.

It would make her so happy if I brought someone home. A woman, I mean. She drops hints about it all the time. It's the only hope she has for the future: my future.

But what can I do? Susan isn't interested. That's the last place she wants to go. It wouldn't matter, but grandmother can tell and she takes it personally. She can tell when I'm unhappy, too—when things aren't going so well. She sees that and gets gloomy herself.

I wish I could bring home, just once, some really good news.

Just for her sake, to see her happy for a change.

Jemuel leaned his head back for a moment to imagine the scene. Indulge in a harmless little flight of fancy. He closed his eyes, but no dreams came.

Fourteen

THE BAR WAS EMPTY NOW, hours after last call. The gate was locked, the shutters drawn, the neon lights cold and dead. So what was all the noise? It sounded like a band rehearsing in there.

Jemuel was curious. He stopped to look through a window, but saw the same dreary scene as always. Should he knock? No, better not. He was already pushing his luck. And grandmother would soon be waking up and wanting company for breakfast. He continued on his way.

Boom! Boom! Boom! Climb the stairs and the sound only got louder. It was coming from the upstairs room.

Susan's nerves were shot. Her stomach was tied in a knot. Her feet and back hurt like hell too, from standing up night after night serving drinks. She was a mess. The dark bags under her eyes attested to the fact that what she needed most was a peaceful night of sleep. Instead, she was up pacing the room like a person possessed. She spun around the bed as if doing laps on a track. She moved as if hypnotized, hardly conscious at all. Only a few thoughts slipped through the headphones and into her head. Mostly it was about the batteries. They were running low, causing the walkman to play increasingly slow. Soon the volume—always on ten—would begin to drop. But what to do? She

couldn't bring herself to walk over to the bathroom, much less back outside and all the way to the store. And she really, really needed to piss. She paced harder, trying to block it out. Downstairs, the fixtures shook with every vaulting step.

While she paced, she cursed. At times like this, she was even more foul-mouthed than Laura. She spoke like someone with Tourette's, or a sailor's thesaurus. Her mouth set forth a steady stream of oaths punctuated only by coughs which brought up phlegm in odd or beautiful colors. She spit these into her hand and peered at them curiously, studiously, looking like a palm reader trying to foretell the future. However, Susan cared as little about the future as she did the past. She cursed them both. "I hate you, I hate you, I hate you. Oh, really? Suck it, asshole. Shit on you, motherfucker. Say that again and I'll fucking kill you!"

Sometimes when she swore, it was at no one in particular, just her mouth adding spice to her thoughts while she walked. Sometimes it was directed at particular people who had insulted or belittled her or caused her to compromise herself in recent days. Other faces she told off were from the distant past. She cut them down and threatened to kill. Then she cursed herself for lacking the courage and words until it was too late. At least half the curses were directed inward, for that or some other regret. Every mistake she had ever made, even errors due to ignorance, was recounted and paraded, enumerated in her mind, and it was then that the curses and oaths were the worst, or perhaps best, and most colorful.

She stopped suddenly as a different sort of thought passed through her head. She stood there growling mid-

pace and scratched the floor with one foot. She let out a low moan and gritted her teeth. She rolled her R's and rolled her eyes. And then, the music died. Fucking cocksucker! She left the headphones on, but thoughts flew in immediately to fill the void.

I'd rather die than walk out that door right now, she thought. Every stupid asshole still awake is gonna make a comment, and I'll be able to hear it. Every moron is going to say something nasty or try to pull me aside and give me a little advice. Try to dump their fears and fantasies on me. I'm so fucking sick of it. But, for that reason alone, I guess I have to force myself to go. Fuck. You can't just let your feelings get the upper hand. If you do you'll end up in a cave, crying all the time.

The people who pretend to care, they're the worst. They'll *never* let you walk down the street in peace. "This is a dangerous neighborhood," they say. "You really shouldn't be out walking alone." If it's not a regular creep pulling over, it's a creep with a gun. A cop. Even they try to mother you. "We're only looking out for your own safety," they warn. "What if something bad should happen?"

Yes, every shithead and his brother took their turn trying to make you feel helpless and small. And who was the biggest mother of the bunch? Jemuel. I want a lover, not another mother! I don't want to be fawned over and cooked for and coddled, I want to be challenged! I want to be feared! I want to be fucked! I want to fight! But that little bitch doesn't have it in him. He needs a little baby, not a grown woman. Treats me like he treats his fucking granny, but guess what? I'm not that old yet. I may not be a kid, but I'm still young.

She cursed, she coughed, she spit, she paced. And while she did, a train passed.

It was loud. It was sexy. It was angry too, and proud. It didn't stop for anyone, and no one tried to stop it. No one stood in its way.

Susan sighed. Now *that's* the kind of lover I need.

Fifteen

THE STEEL RAILS SHIMMERED LIKE mercury in the trailing light. Laura stepped over them and walked back to the porch with mixed feelings. Well, it felt good to come to a decision, at least. Should we try it again? Alright, make it two out of three. If the *next* train is carrying munitions, it's also taking me.

Now, should I prepare a statement? Or will my blood and brains scattered over the tanks be statement enough? Maybe I'll be the first casualty of American weapons to actually be counted. No, who am I kidding? The papers won't say anything. They never cover suicides. Only when you kill other people do you count.

It would save a lot of trouble this way. We wouldn't need to make bombs or use guns. We wouldn't have to worry about disguises, escape, or arrest. And best of all, I'd be dead! No, just joshing. The best part would be no more waiting. The waiting is worse than death.

"Just as soon as my grandmother goes." That's what Jemuel always says. Dies, he means. Which was fine at first. That way he can't shame her, or worry her to death—that makes sense. But how can you wait for someone to die before you really start living? Now it's turned into just another excuse. We'll be old and grey ourselves and still be

waiting. She'll outlive us all—and in the meantime, the war rolls on, right past us. All our plans and good intentions haven't slowed it down one bit, and neither have the bricks. But what else can I do all by myself?

It would be better to die than to go on living like this, in limbo. In denial.

Either that or just admit defeat. Give up the fight. Give up trying not to drink, while I'm at it. In fact, I'll pick up some more habits. Go down to the habit shop and get myself a model train—quit messing around with the real thing. I can set it up in the basement like a good American. Buy some fake trees and a handful of those little plastic hobos. Glue 'em on the back of the caboose. See those little rascals? That one's Aaron. And the one with the cool hat? Hey, that's me!

Or, it *used* to be.

Well, I'll be damned. Will you take a look at that?

Laura's mouth hung open in shock. She smacked her head with her hand. The van in the driveway was rocking violently back and forth.

Speak of the devil! But he's not in there alone. I must have missed something. Getting rusty, man. Time to retire, for real. Some Sphinx you are — even the neighbors have people sneaking in on your shift!

She shook her head and took a sip.

Sixteen

By NIGHT, THE VAN WAS AN ICY TOMB. By early afternoon it had turned into a toaster oven. It was stiflingly hot in there, but the minute I rolled down a window, mosquitoes would come in. So would my cats, stepping all over my face with their wet, muddy feet while I was trying to sleep. Licking me with their sandpaper tongues which had probably minutes before been lapping up vomit outside the bar or gnawing on the carcass of a dead squirrel under Laura's house.

Ech. Barbarians. Rotting little cretins. Furry little croutons. I kicked open the door and called for them now. One by one they came, settling on the small of my back in a little pyramid.

Perfect. It reminded me of being on tour, with everyone piled on top of each other sleeping and the van broken down on the side of the road, smoking. Those were always my favorite times, traveling. My fondest memories. Now it was like that every day. If only I had something to smoke.

Yes, a broken-down van was the perfect place for a person like me. All the appearance of movement and direction without the threat of actual change. You could be an irresponsible dirtbag lying around all day reading books and pissing in bottles while the world went by out the window. Just like on tour, but without the inconvenience of having

to leave the house or meet new people. Or having to per-
form. I'd always liked the road itself better than the places
it had taken me, anyway.

Two bookshelves ran the length of the van, one on each
side of the bed, stacks of books I'd spent years accumulat-
ing, waiting for the chance to read. Well, wait no longer.
Now that I finally had the time, I seemed to be in the mid-
dle of all of them at once. No sooner had I picked one out,
I changed my mind and grabbed another, or reached for my
reference section to check a fact or look up a word. And
each time I moved, so did the cats, running up and down
my back like passengers on a sinking boat, trying to even
out the weight and avoid being thrown overboard.

I'd rewired the van's stereo to run off an extension cord
from the house. That much was easy—but it still had the
same tape in it that the original owner had jammed in care-
lessly, permanently, some twenty years earlier, and nothing
could get it out. Screwdrivers, pliers, plungers, chopsticks,
crowbars—everything had been tried. It was as permanent
as the voice in your head, and almost as familiar. I turned it
on now, softly, after noticing I was already singing one of
the songs. One of the schlockiest, schmaltziest songs ever
written. But how can you get something out of your head
except by embracing it?

I reached for a novel and settled in. But something wasn't
right. I couldn't concentrate no matter how hard I tried.
I was disoriented, maybe an after-effect of a dream I couldn't
remember. That sometimes happened. Something was
gnawing on me oddly, a feeling like I'd missed a cue or a
clue. My head was crowded and I was trying to swim
through all the murky crap to a clearing where a little light
was shining down. But I kept getting lost.

My mind grew hazy, the words of the book ran before my eyes, and meanwhile, I could see other eyes in the corners which were not mine. They peered over my shoulders at the turning pages. The cats. Silent they were, brooding, pensive. Was it me they were imitating? They never meowed, not even once. Not a sound came from their filthy mouths. But there were other signs. Now and again, one waved a little paw, trying to catch my attention.

"Okay, okay, I get the idea," I cried. I'd spent years ranting about the stupidity of people who talked to their pets. Then I became one. Well, that's life.

I sat up, scattering the cats. They clambered after me as I climbed out of the van toward their empty plates.

Seventeen

TRUTH BE TOLD, I TALKED TO MY plants too, but only a bit. They were mildewed, bug-eaten, and appeared to have been trampled by some large animal, the poor things. So I moved through the garden offering a few comforting words. I staked up the fallen vines, pinched off the dead leaves, and picked the occasional piece left over for Laura and I to eat. Not a lot of yield, this lot. For all I'd put into it, the soil still sucked. I managed to scrounge up only enough for a small salad and some soup. I turned on the gas for the Coleman stove, then decided against it. No one answered when I knocked on Laura's back door, so I let myself in. More room to work in there.

The lady of the house hadn't been looking so good lately —I was getting a little worried. Never had known how to take care of herself so well. Her old girlfriend was the one who did that. That girl, she could cook! A born caretaker, or so it seemed. A big part of her identity and happiness seemed wrapped up in it. I wondered, was that what made her pick Laura out of the lineup? Even from a mile away, you could see a cripple looking for a crutch.

But then, what made Laura pick *her*? What did Laura like in girls besides... Well, I can't say it, not even to myself. She liked girls, in general. That's a nicer way to put it. She

liked girls who liked her. Not the worst kind. But not usually my type. Ha.

No, Laura was not the most discriminating judge when it came to women. With that one, though, she had really struck gold. Talk about impossible shoes to fill. Not only a loving partner, but a great guitarist too. When she left, it was a double breakup, Laura and the band. Who wouldn't be reeling from that blow?

As an all-around replacement, I was strictly second-rate, especially when it came to cooking. But compared to my guitar playing, anything sounded good. So, I did what I could. I tossed the salad and stirred the soup. Something was better than nothing, which is what Laura would probably eat if I weren't around to keep an eye on her.

But who would keep an eye on me? No one, luckily. I danced around the kitchen making obscene gestures, knowing no one was looking. I put on a record and sang a tender ballad to the salad.

That's when I saw it. An interloper, hiding in the greens. A hair, and not one of mine. I picked it out and held it up to the window. Long-stemmed and red like a rose—I'd seen its kind before. They still turned up on my blankets and clothes. Little tiny bombs. Time bombs. The last little pieces. I put it on my tongue, but the oil and vinegar had eradicated any taste of her that might have lingered. Still, I swallowed it like a pill. My medicine. Thank you for reminding me, though I have yet to forget.

Suddenly, all the forgotten dreams flooded my head. Earthquakes, fires, awkward sex, ailing parents, and Laura really angry. Now I remembered tossing and turning all night trying to shake off each one, only to have it replaced by something even worse. Shaking from the cold, too, as

I did every night in the van.

Finally, through the veil of sleep, through the scariest of all dreams, came the faint sound of someone making their way through my mess. Gingerly, knowingly they stepped. Then a soft voice so close it tickled my ear. It was the voice I had been longing to hear. The one I had been waiting for. "Scoot over so I can join you," it said. "Then you'll be warm."

I feigned deep sleep so as to better savor the moment, but the smile on my lips threatened to give me away. With her returning, all the nightmares just disappeared, evaporating into thin air. I moved over happily, obediently, and waited.

But when I woke up, no one was there.

Eighteen

SUSAN WAS ALREADY DRESSED AND looking out the window. Not much to see, really. A few rooftops. The trainyard in the distance. Yet sometimes you caught yourself staring out into that distance for hours on end.

Behind her, Jemuel lay in bed, fast asleep. She turned around to look at him. A blank canvas. She gently pulled off the blanket then prodded him a little. No reaction. She moved his arms into ridiculous positions, brushed his hair forward so that it covered his eyes. She dipped her fingers into the coffee then stuck them in his mouth. Nothing.

"Jemuel," she whispered in his ear. "Were you *really* just riding around when I found you last night on the street? Or were you looking for me? Me, your worst nightmare. Tell me the truth. I love you, I love you, I love you. Just kidding. Keep dreaming. Jemuel, can I borrow your gun? Hey sweetheart, I'm going down to get the morning paper. Hey loser, I'm going to give your breakfast to the bums in the alley. I'm going to run off with the gypsies. Hey fucker, wake up! Rise and shine! Reveille! Atten-shun! Get out!! Oh, it's no use."

Spending the night with someone was one thing; the morning, quite another. That was the difference between sex and romance. Nothing Susan hated more than waking up with someone giving her those "marry me" eyes. No,

you should never be there in the morning when they wake up. Bad form. It was always better to spend the night at their place, that way you could escape back to your own hole when the time came. Wash up and put your thoughts in order. Sometimes she wondered if Jemuel lived with his grandmother just so he had an excuse to spend the night at Susan's instead of bringing her home. Wouldn't want to give the old bat a heart attack, after all. "But what about *me*?" Susan demanded. Jemuel just lay there. Not even a rise.

Well, it's the same old shit, she thought. He's dead to the world in my bed while I'm ready to get on with life. What a drag. Maybe I should take photos? But who would want to see them? This sucks. I can't even leave him here to let himself out. No, the only entrance is through the bar. He'd stumble down right into a roomful of early drinkers, with my boss there behind the counter. That would be the end.

Trapped, I'm trapped. Like that song. And that's the only part I know, those two words. Wish I knew the lyrics to more songs all the way through. Hey, that's a good wish. Maybe I'll use it.

She picked up her coffee cup and walked downstairs into the empty bar. It gave her a peaceful feeling, the way public spaces do when empty of all the people. A faint echo resonated, a slight hum left over from all the conversations which had passed in that place, not all of them pleasant. She opened the front gate and picked up the paper. She skipped the front page and turned right to the obits. Then the local "news." Then the classifieds and wedding and legal notices.

She was lying on the pool table when she got to the letters to the editor. She laughed a little. Weird. Isn't that

49

Aaron's old girlfriend? She sounds like a fucking nut. Well, it figures. But, writing to the local paper even after you've moved to New York? *That's* really weird.

Jemuel came down the stairs.

He was blocking the light.

"Jemuel, I'm trying to read," she said. But she stretched out and rubbed against him like a cat. "Baby, where have you been?"

Nineteen

OUR HAPPY COUPLE LAY THERE in a post-coital embrace, filled with bliss. But, they were also filled with the craziest, most absurd, vile, and inappropriate thoughts for that, or any other, occasion. Give the pot a good stir and all sorts of odd stuff floats to the top. Childhood memories danced with outrageous fantasies in their heads. When they broke the silence, it was not to speak their most intimate thoughts, but to disguise or obscure them from each other. They struggled to establish a rapport to replace the quickly diminishing physical one.

"Jem," she whispered. "What are you thinking?"

Normally a little tight-lipped, something about being with Susan always made Jemuel anxious to talk. She brought out in him a sense of wonder so full he wanted to burst. Still, he tried to hold back.

"Oh, nothing," he lied.

"No, really."

He stalled, but saw she wasn't ready to let him retreat into himself so easily. Sometimes you needed to hear the voice of the person next to you, even he knew that. Otherwise you felt alone, or like you were lying there with a stranger. But feelings were hard to put into words.

"Well..." he started, "I was thinking about something

that happened the other day. I saw a bag lying on the street. A little brown bag, the kind you carry with you to school when you're a kid. Somebody's lunch, it looked like, but I thought I should check. Could be something important that had been lost. I could return it—I wasn't going anywhere important. But when I picked it up, I almost jumped. I let out a little yelp. It would have looked pretty funny, if someone was there to see. I dropped it like a burning coal. I thought it must have been my imagination—but then, there on the ground, it happened again. The bag moved. And guess what? A little bird flew out!"

Susan shook her head with a look of concern. "What was it doing in the bag? How'd it get there? Was it hurt?"

Jemuel smiled. She had entirely missed the point. But what was the point? He wasn't sure.

He really is a little boy, she thought. Checking under rocks and opening up flowers, hoping a bee or butterfly will come out.

Silence gathered, and with it a growing sense of discomfort. The chasm between them stretched and yawned. Jemuel searched for something to bridge the gap. "Laura said I deserve better than you," he suddenly blurted. For some reason, other people's feelings were always easier to express.

"Oh, really? She said that?"

"Yeah. She said you can't treat people like they're trash."

There. He'd said it. He felt better now. Secrets kept people apart. It wasn't good to hold things back which could be talked out instead.

"She thinks she can tell me how to act? Trash, huh? That's what she called me?"

Jemuel saw himself as the moderator—the calm mid-

dleman, the peacemaker—even in conflicts he had created. He was pleased, too, to feel once again engaged with Susan. Back on the same page.

"I'm going to see Laura soon," he said soothingly. "I'll tell her to come work it out with you. I could never figure out why the two of you weren't friends."

Twenty

PERFECT TIMING. Laura walked in the front door just as dinner was getting done. But she seemed flustered. Her face was flushed, and not just in the radiant way it usually looked after a jog. She grumpily stuck her finger in a pot simmering on the stove and said, "Needs more salt." It was my wheatpaste, not the soup. I nudged her towards a seat.

"Something wrong?"

"Nothing." She thanked me for the food but ate angrily.

Slowly, she seemed to cool down a bit and catch her breath. I kept quiet. Any attempt to cut to the chase and I knew she'd close up completely. She seemed secretly eager to talk, but I waited for a signal. It finally came as a loud belch when both of us had finished eating and the dishes were being cleared. "I'm thinking of starting a new band," she began.

"*Really?*" That caught me by complete surprise.

"Sure, why not? I figure it's the only way I can be pissed off without someone trying to fucking comfort me and ask what's wrong. No offense."

"None taken."

"With a band, everyone dances and sings along. You get angry and scream and no one thinks you're crazy or tries to get you to calm down. They just think, good show!"

I nodded. Band as disguise. It had worked well, too. It wasn't until her band ended that we started to really listen to Laura and recognize how serious her problems were. But all that was beside the point. I knew Laura's circuitous way of talking. She was trying to get at something else.

"Look," I said, "Pretend I'm your band. Ready? One, two, three, go! Bffffffffffffff! That was where you were supposed to come in."

"Aaron, I'm not in the mood."

"Come on, at least tell me what's on the set list. An angry song? A love song? Betrayal?"

"I *don't* want to talk about it," she snarled.

"Give me a hint or at least a count."

"Forget it. It's really stupid. It's just this little thing, I shouldn't let it worry me. It's just, Jemuel, do you know what he did? I was trying to be supportive, right? You know how sometimes it's nice to have a friend who hates your girlfriend? Don't look at me like that, you know what I mean. Not *hates*, necessarily, but is just a little wary of her. A friend who's watching out for you, watching your back."

"Of course. That's what friends are for."

"And when things go bad, they don't take your girlfriend's side. They don't start listing off her good qualities."

"Never." I felt a little guilty now.

"Later, when you get dumped, your friend keeps up morale at the front. Your friend is like, 'She wasn't good enough for you, anyway,' and you're like, 'Yeah, fuck that bitch.' Even though secretly you're pining away and plotting to get her back. Your friend understands this too, but doesn't let on."

"Believe me, I know."

"So what does that cock do? He goes crying to Susan telling her every word I said, when I was just trying to comfort him."

"Unbelievable."

"Truly! And you know what he told me, in that annoying shrink voice of his, that Mr. Rogers voice? He said, 'I'm just being honest. That's communication. It's healthy. Of *course* I'd tell her. I'd want to know if someone was mad at me.'"

"That's not honesty, that's being manipulative."

"I know, that's what I told him, I said, 'That's not honesty, you stupid piece of shit, that's just fucked up and rude. You're an asshole.' Then, to top it off—and this takes the cake—he tells me, 'Well, you and Susan should talk about it. She's really pissed about what you said.'"

"Uh oh."

"Uh huh. Mad at *me*? I'll kill her! Just let me get my hands on her. She wants to fight? I'll fight! Little miss stuck-up walking around on the clouds thinks she can steal my friends and turn them against me? She's *over*. Mark my words, I will have my revenge."

Twenty-one

WE SMOKED A LITTLE AND SAT in the kitchen, nursing our separate thoughts.

I was thinking about the difference between a good and bad roadie. When six foot flames are leaping out of the van, the bad roadie is the one who freaks out even more than the band. The roadie is screaming and crying as if *their* life just ended, not yours. But the bad roadie is *also* the one who remains completely calm. Who makes everyone else look unreasonable in comparison. That's sort of a power trip, being calm right in the middle of a storm.

And what about the good roadie? No such thing.

I looked over at Laura. What she was thinking, it was impossible to tell. I wasn't sure if it was safe yet to change the subject. Or maybe she wanted the subject changed but couldn't do it herself. Wouldn't want her anger to appear to have passed so easily, as feelings often do. Nothing more embarrassing, or common. Wanting to wind things up on a different note, I asked, "Any women in your scopes?"

She laughed. "Nothing. Zilch. Nada. And you?"

"The same."

She eyed me curiously and edged closer. "Good. So you won't mind passing on a little message for me?"

I screamed. The chair legs collapsed as I fell back with

Laura on top, her teeth sunk deep into my neck.

"Aaaaaaaugh!" I lay on the floor, one hand nursing my neck and the other holding the part of my head that had hit the sink on the way down. Both were throbbing with pain.

"Oh, poor baby, are you alright?" she sang in a mock lullaby, a vulture imitating a dove. "Let me get you a band-aid."

She went into the bedroom then returned a minute later with a roll of duct tape in one hand and a beer in the other. "Well," she said, "take your pick, that's all I got. Maybe *Susan* has a band-aid for you."

"Oh, spare me." I took the beer and sat back against the wall holding my head.

It's always like that. Someone throws a pebble and before you know it, the ripples turn into waves.

Twenty-two

SUSAN STARED AT HER CEILING thinking, *What am I feeling now?* Every half hour she got up, poured herself a new cup of coffee and attempted to start the day in earnest, but each time she gave up and crawled back under the blankets. Half the cups she spilled or tipped over. Her hands were red, the sheets wet and stained. She put on her walkman at top volume and walked around in bed, still on her back. Moved her feet, that is. It helped her think.

She tried to take stock. Nothing there. Of course. It always took a while for anything that happened to her body to reach her mind, and vice versa. Sometimes a day or two. Or *years*, she thought darkly. I'm still only starting to feel things done to me years ago.

Susan had spent her entire lifetime—her entire lifetime! —just trying to get that feeling everyone else took for granted. The sense that her body and her life were her own. Not someone else's property, not someone else's business, not someone else's pride or disgrace. Piece by piece, she'd built up a state of independence which didn't ask favors or approval from anyone. She didn't want to change or control anyone else—that's what people didn't understand—only to be in complete control of herself. Yet no one would accept that and let her be!

She rose as the sun was going down. Still a little time left before work, but only a little. Quietly, she closed the door behind her.

Across the tracks, Laura and I were in the kitchen. I washed the dishes, looking out the window so she wouldn't notice my eyes misting up. The strangest things make you remember. Especially the things you do trying to forget.

Laura didn't notice. She was lost in her own world, one even smaller than the little world we were spinning our wheels in, digging a deeper and deeper rut.

Susan walked with her headphones on at full volume, staring straight ahead, trying not to think. Laura sat on the porch waiting for trains, trying not to drink. Jemuel rode by as I watched out the window. Seeing the look in Laura's eye, he turned the other way.

Twenty-three

SUSAN TOOK THE SUBTLETIES OF bartending very seriously. She delivered a kind word here, a licentious insinuation there, a home remedy, a bit of romantic advice, and—when called for—a poisonous put-down, all with grace and a certain dramatic flair. She was a natural master of ceremonies.

She kept two moods on a low flame, always at hand and ready to serve up at a moment's notice. Righteous indignation and loving affection. Susan was mercurial, volatile, switching between the two extremes. But she was also the consummate bartender. She could mix and match to suit any occasion, and had a knack for fine-tuning her tone and manner—her mask—to complement every customer. They liked that.

Tonight, her cups were overflowing. A minute earlier, she'd been fantasizing about some improbable sex. Now she was training for an imaginary fight.

You think he deserves better? Fine, you can have him. Be my guest! He's all yours! But before you start calling other people names, take one good look in the mirror!

Then the phone rang. Susan could never manage that emotional detachment other people had when a phone call or some other interruption came. That ability to step out of whatever thought they were in the middle of at the moment

and talk in an even, cheerful tone. No way. She could only answer honestly, with whatever angry, crazy, or filthy words were right at the tip of her tongue. It had gotten her into a lot of trouble over the years—but not as much as being dishonest and detached in the years before that.

"Hello, Susan's dump. Where you get treated like trash. Where you deserve better. Calling about the job opening? Good. Try-outs start tomorrow." She slammed the phone back in its cradle without bothering to listen for a response. No doubt it was Jemuel calling to calmly discuss the latest turn of events.

What she needed most was a good screaming, cursing, crying fight. But how could you fight a guy like that? He didn't scream, curse, *or* cry—not *ever*, as far as she could tell, and she'd certainly done her best to bring them on. No, he just stirred up your anger and left you holding the bag. With a fucking bird in it. Dumbass. Putz.

Even a baby screams and cries, she thought. He's not even a baby. He's not human. Is it too much to ask for him not to be so fucking reasonable all the time? It's unfair. If he had any demands, anything he stood for, anything he couldn't stand for? Then maybe we could have had a real relationship. Instead, he makes me set up the rules of the game, and then, if it doesn't go well, *I* get blamed. He doesn't have to take any responsibility at all. Just a poor boy, a hapless victim. I can see them pointing, "Look what that mean, demanding girl is doing to him now." But what is he doing for himself? NOTHING!!!

Some yuppies at the end of the bar kept snapping their fingers. Susan turned on them. "YOU GONNA JUST STAND THERE SNAPPING LIKE CRABS? ORDER IF YOU'RE GONNA ORDER!! OKAY, FINE! COMING RIGHT UP! THREE BUD

LITES! YUP, YOU COULD STAND TO LOSE A FEW! THAT'S NINE BUCKS! PLUS A TIP. THAT'S SOMETHING PEOPLE WHO AREN'T ASSHOLES LEAVE FOR PEOPLE LIKE ME WHO WORK FOR A LIVING."

"Maybe you should drink less coffee," one of them suggested jokingly.

"MAYBE YOU SHOULD SUCK MY DICK, ASSHOLE! MAYBE YOU SHOULD DO US ALL A FAVOR AND DIE. MAYBE YOU SHOULD START WALKING WHILE YOU STILL CAN."

Susan turned around and watched the departing yuppies in the mirror. A round of applause came from the regulars, but the gesture had the opposite of its intended effect. Susan looked at herself now and shook her head.

Cheerleader for a bunch of redneck drunks. That's how low I've sunk. Maybe I *should* start drinking less coffee.

Twenty-four

THE REGULARS AT THE BAR left their tools by the door after each long day of work. They sat together washing down their frustrations with cheap beer while they bonded about how much they hated the boss. Susan joined the chorus even though her boss was not so bad. That wasn't important. It was a way of talking, of commiserating, of being together. If one of the regulars had a problem, they could confide in her. And if she had a problem, she could blow off steam by taking it out on a customer. An unfortunate irregular, that is, who happened to straggle in at a bad time.

In this way, everyone got to share and compare and forget their troubles together. Until a familiar pest entered the picture. Me. Pee-ew! The regulars made faces as if in pain. Not only did I apparently not drink, I didn't even complain about my job, leading them to assume I didn't have one. However, nothing was further from the truth.

I despised the regulars—though I would have joined them in a minute, given the chance. But how could I? My work troubles couldn't be shared. I couldn't whisper them to the bartender nor stand on a table and orate to the angry mob. Even when I took a big risk, I could not brag. No, I could not speak of it at all, not even to Laura, though I had a feeling she knew. She had private parts of her life, too. An

unspoken understanding like ours was best—but I missed other kinds of bonds, ones that were more vocal and communal.

How I wished I could just stroll into the bar after a long stretch of work like everyone else. Put my paint on the counter, set my bucket of paste at the door, hang my stencils and gloves up to dry. Just another regular guy.

"Friends," I'd announce to the whole room. "Did any of you leave a genocidal maniac downtown? Well, no worries, I've got him right here. Claim him if you'd like."

And, as a severed plaster head rolled out from my bag, the crowd would erupt in a cheer.

Keep wishing, punk.

Alas, a life of crime is a lonely one.

Twenty-five

"HARD DAY?"

Susan spun around. "Aaron! I didn't even see you come in."

"Yup. Got anything on?"

"Sure thing, honey. I could use a fresh cup, too. I'm a little shook up today. Not quite myself."

"Shook up? Or not quite yourself?"

"Okay, okay. So pretend you don't know me so well. Hold a sec, I'll be right back."

Susan slipped behind the curtain and put her angry mood on the back burner. She took a big breath, then came out with two cups. Raising one to her lips, she eyed me over the edge. "Well, I'll be," she said.

It took me a minute to catch what she meant. "Oh, this?" I rubbed my neck.

"Oh, this?" she echoed in a silky, teasing voice. "Well, well. I guess we all have our secrets."

I gulped. "Try to, at least."

Susan pulled glasses from the rack, polishing them. She looked bothered. Was she *jealous*? I beamed. I felt good. I looked over her shoulder at the mirror. Other women in the mirror.

"Now you're pushing your luck," she warned.

"Right. Sorry."

Susan might not be the only person to get the wrong idea, I suddenly realized. Her Rambo boyfriend was likely to bomb my van if he heard about the hickey and came to the wrong conclusion. I hiked up my collar.

"To tell you the truth, I cut myself shaving. You try to keep calm, right? But then what happens? You start thinking angry thoughts, you start singing angry songs. Next thing you know, it's like—"

I motioned a slit neck.

She eyed me skeptically. "Are you high or something? Cause you're acting really weird tonight."

"Nah. Just spaced out. No sleep lately."

Pulling me close, she breathed in my ear. "I'll bet. Who's the lucky lady?"

I shifted uncomfortably in my seat. "No one you know."

"You'd be surprised what I know. I have my little spies. As opposed to you, my big spy." She held up a paw and made a playful, scratching motion.

When I looked at her oddly, the regulars arched their brows. From the other end of the bar, they eyed us curiously, awaiting the next move. But I was in no mood to be stared at and scrutinized. I growled back. Stupid drunks. Drooling idiots. Bar things. Always staring at me like I'm some kind of freak. See how it feels now. Who's the freak now, you fucking freaks?

I didn't realize I was thinking out loud until Susan poked me in the ribs. "Aaron! Shush! They might be a little disagreeable, but they are my customers, after all. Our love won't pay the rent."

She always had a way of putting things that precluded any argument.

I turned over the tip jar and started to separate the change. Then I stood up, walked over to the jukebox and pulled the plug right in the middle of a song. Ignoring a line of hostile stares, I sat back down at my place.

"Why'd you have to do that?" Susan pressed. "It would have been easier to just turn it down. The volume control is right here behind the curtain. You could've just asked."

"I'm sick of asking for things," I said. "And sick of waiting for things to happen, too."

"Yeah, okay." She nodded. "I know what you mean."

Twenty-six

EVERYONE SEEMED UNEASY. Uncomfortable in their old skin and growing restless. Even Laura, never one to do things aimlessly, was out on a seemingly aimless late night stroll. She was looking at the old buildings as if they were new. Gotta get out more, she noted. Was this thing always here? Who lives up there, I wonder. In a window, she saw a reflection of herself standing there pointing.

I look like a retard, she realized. What's my problem? It's like I'm showing myself things instead of seeing them. That's fucked up. That's crazy. I can't even think, either. Instead of thinking, I tell myself things. Not good. When I read, it's like I'm reading *to* someone. Or like someone's reading to me.

It's weird. Like there's two different people discussing everything, showing each other everything. Arguing with each other. What's up with that?

Well, I finally caught the train. That's one thing we can both agree on, at least. Might as well just walk around a while now. Nothing stopping me. Nothing else to do anyway. There won't be another one tonight, I'm almost positive.

Yeah, I nailed it this time. Hoo-boy. So where's the cheering crowd? It's not like when we had the band, that's for

69

sure. Think this will make it into the scene report? Not likely. Not unless I write one myself.

"Laura (formerly YOUTHFUL, formerly HOPEFUL) celebrated the release of a STEEL PIPE, a can of PINK HOUSE PAINT, and a BOWLING BALL. All three were distributed during a massive show of AMERICAN MILITARY BRUTALITY at the RAILROAD TRACKS, one of many in recent weeks."

Let's see, "The steel pipe was well received by a JEEP WINDOW. The pink paint did a cover of TWO MAUSER TANKS. The bowling ball ended up missing the show due to technical difficulties, but will return."

Ha ha.

No, you just can't write about that stuff. Or even talk about it. That's the problem, all the best stuff has to be kept secret. So the most boring crap is what everyone writes and talks about instead.

"Laura appeared in good spirits despite nearly tearing her arm out of the fucking socket during the performance, adding to the pain she was already suffering from the KNIFE WOUND IN THE BACK delivered by a certain straight-edge bartender who only yesterday was Laura's latest unrequited crush. On a revenge mission now—but don't tell anyone cuz it's a secret, okay? And so it shall remain. Last seen headed downtown, Laura had this to say: "Love? Who needs it?" I mean, "Fuck it, who cares? I'm drunk!""

Dot dot dot.

Inside the bar, Susan and I were running through the closing rituals. Counting cash and breaking glass, mopping floors and hosing off the mats. She shepherded the last callers out the door. There was a certain comfort in bringing a curtain down on the day and a certain conspiratorial joy to see, and be, behind that curtain when the action con-

tinued offstage. Or conversation, as it stood between Susan and me. Our action was all talk.

"Got some news you won't like," she said. No joking around now. Her voice didn't have that teasing, waitress lilt once the lights were off.

"Some cops were in earlier. Off-duty, supposedly, just chatting it up. But they asked a lot of very pointed questions."

"About what?"

"The wheatpasted fliers, the windows at the armory, the break-in at the Downtown Improvement Board. Everything that's been in the news lately. The statue downtown."

"Andrew Jackson or Columbus?"

"Neither," she laughed. "The Ninth Street gnome."

I eased up and let out my breath. Let the cops chase after some gnome thieves.

Susan, seeing my sense of relief, shook her head. "Then they asked about you. By name. Laura too."

"Crap." I tapped the counter nervously. "What did you say?"

"Excuse me?" She glared at me with contempt. "Were you born yesterday? I'm not a bartender for nothing, you know. We're famous for protecting our sources."

Twenty-seven

THE NEWSPAPER TRUCK DROVE BY delivering tomorrow's headlines. The garbage truck went by. The homeless guy passed carrying a bag of empty cans from the bar. Everyone waved, and Jemuel waved back. The record store was like a little lighthouse shining warmth onto the empty downtown streets, with a silhouette of Jemuel in the window.

Someday I've got to get some curtains, he was thinking.

I mean, it's cool to be the friendly face of downtown, but sometimes I'll be picking my nose or worse, then realize there's someone right outside. Besides, I think I'm getting late-night-at-the-record-store hair.

It was true. Jemuel's hair had been shaped by a long evening of absent-minded worry and was now sticking straight up ala Robert Gordon or Dr. Seuss. He was ambling around cleaning header cards and grooming the shelves, culling out old crap here and there and pulling out things which were misfiled when he found them. In the store and in his mind.

Poor Laura, he thought. She's just like the people who work here. They get an idea one day, then abandon it the next. They can't understand what it means to choose something and just stick with it, to slug it out through thick and thin. They don't know the value of persistence. They're too

impatient.

I try to tell her, how would I have gotten this far with Susan if I'd been like you, impulsive, ready to give up at the drop of a hat? I explained it that way, and what happened? She got mad! But I love her for that, too. We're such opposites.

Sure, I get excited too. But I never lose sight of the goal. Like last night when Susan found me and brought me home, I thought, "Well, my persistence is paying off."

Then, today, she tells me we're through.

I'll admit, it caught me off guard. But then I realized, if that's what she wants, I'm happy for her. Really.

"Alright, Susan," I said. "If that's what works best for you, that's what we'll do. But can I just keep one tiny spark of hope alive in the back of my mind that someday you'll want to see me again?"

Jemuel smiled at the memory.

Well, she got this look on her face, this look of pure hate. And that's when I knew there was still hope.

What am I supposed to do? Try to convince her she's wrong? That's ridiculous. The best thing I can do is just listen and not try to change her. If she doesn't like me for who I am, it's probably because she knows I could be so much more. She's right. So, I'll take the opportunity to try to improve.

Why do people think that's weird? And why do they act like Susan is pushing me around just because I respect her decisions? Not that I care. I'm only trying to see it through their eyes—but I can't.

Say you have a record store, and it's just a huge mess. No one can find what they're looking for, no one can find what they want. So you agree to set it up a certain way. You can

change it around, just like Susan and I can change our arrangement. But first you need rules in place so you know where you stand. You work from there. And if you break the rules, you might get punished. But you stick with it. You don't just give up if something doesn't work at first.

All you can do is hope it works out in the end.

There's the cops now. Even they wave. The same cops as when I was a kid. And even some of their kids, people I used to play with in the sandbox, I see them driving around with a badge now, just like their dads. Ever since they found out I was in the army, they think I'm their good buddy.

Let's say I flag them down one night, act like I just saw a crime. When they come to the door, I shoot the first one right in the face. Even if he's got a partner with him, chances are they won't be taking precautions since it's me, the friendly guy who they wave to every day. Yeah. I can take cover behind the register and keep them from getting to their car and unlocking the real firepower.

But then what? Rats. Looks like they've got someone else to deal with for now.

Twenty-eight

I WAS CUTTING ACROSS THE parking lot when I saw the red, white, and blue lights. I kept walking but the car turned sharply and skidded to a halt, blocking my path.

"Don't move!" yelled the cop, jumping out of his car.

"I said, DON'T MOVE! Did you hear me? Okay, got any guns, knives, or weapons on you? Now what's in the bag? Mind if I take a look?"

What could I say? Refusing was a pathetic, useless gesture. But we all have to draw the line somewhere.

"What's that? Speak up."

"Yes," I said. "I mind."

"Well, well, looks like we got ourselves a *lawyer* here."

The cop's partner, back in the car, gave a little laugh.

"Any spraypaint in the bag?" He picked it up and shook it. "A lot of vandalism in this neighborhood lately. Let's see your hands."

He smelled them. That couldn't have been pleasant.

"Where are you headed? At this hour? Doesn't that seem strange to you? And taking this back street? Why are you coming this way if your house is in the other direction? Have you been drinking?"

"Yes," I lied. Drunkenness, the only acceptable excuse for unusual behavior.

"Well, you'll have plenty of time to sober up where you're going. I'm booking you on Suspicion. Guess you already know, since you're so smart, that once you're under arrest we don't need permission for a search. Now turn around."

He tightened the cuffs around my wrists while his partner emptied the contents of my bag onto the ground. She looked disappointed. Nothing incriminating at all. Maybe that would keep them from searching my bag next time, when it was full of spraypaint. But probably not.

I was treated to the usual creepy, degrading comments. Time-tested stuff designed to make you feel small and powerless. Always works, too.

The two cops traded laughs about the way I looked and smelled. They discussed organ size, saying only small men have to prove themselves by mouthing off the way I did. They speculated about all the ways I'd have a chance to prove my manhood in jail.

Ho ho ho. Getting arrested was a strange mix of total anxiety and total boredom once you'd been through it a few times.

Just shut the fuck up and get it over with.

The jailer gave me my own cell and even brought some dinner, despite the late hour. So why make a big fuss? Why bang my fists against the bars or even try to figure out the right angry words? It was pointless. The cops had left.

I tried to humbly accept my fate, but underneath my paper-thin layer of Buddhism and world peace lay a raging storm of murder and anger which would surely find its outlet elsewhere, probably much later, on someone who didn't deserve it. That was the most shameful part of the whole thing. That was jail in a nutshell.

It was Saturday night. What if they held me through the weekend? The TV would be blaring all day long in the other cells. Religious programming, a fate worse than death. Suddenly the true weight of being in jail dawned on me. I hung my head in defeat, but even that felt foolish. Why say "ouch" if no one is around to hear it? Just to prove your own humanity, I guess.

I scanned the graffiti carved into the cell walls. "All life comes from a cell"—I remembered reading that slogan somewhere. This graffiti was mostly just hearts and initials. Still messages of hope, in their own way. I looked suspiciously to see if any of the hearts had *her* initials.

I clenched my fists and pressed my head, hoping it would pop. What was my fucking problem? Scared some other guy might steal her away from me? It was too late! One had! Get over it!!

But how? The longing, loving feelings hadn't just left when she did. And neither had the jealousy, the pettiness, the paranoia, and the constant fear that I'd lose her.

She was gone, but the horrible fear that I'd lose her remained.

While I'm in *jail*, she's out messing around with some other guy!

Okay, cut it with the theatrics already. They won't do you any good.

Twenty-nine

LAURA LAUGHED TO HERSELF. Yes, drunk she was. And still shaky from the adrenaline rush of meeting the train, hours after the fact.

Both things were bad, she knew.

It was unprofessional.

It was sloppy.

Calm, cool, and collected—that's how you needed to be. Dispassionate. Nothing to louse up your motor skills or critical thinking.

What if something unexpected should come up and you were too excitable or too slow to properly respond? Like cops lying in wait. What then? Getting arrested now would ruin everything. Once you were on their radar it was nearly impossible to get off. Anonymity was the best weapon you could have.

Pleased with the speech, she stepped out of the judge's chair and into the witness stand.

Well, I got the train and got away, right? Isn't that what counts? So why not celebrate? A little shot to the heart, it steadies the nerves. Being too cautious would be unnatural. I'd get nervous. Then I'd get caught.

Nah, quit making excuses for yourself.

But what if Jemuel is all talk? What if he doesn't really

mean it? What if he doesn't sit around thinking about our plans the way I do?

There's the record store now. So go talk to him. Ask.

Oh, fuck. Piss. I just figured it out.

It's because she used to always be there, right by my side. She-who-cannot-be-named number one. *That's* who it is I'm pointing for. That's probably who I've been talking to all this time, and not myself! Now it all makes sense. So I'm *not* crazy, after all. I just got so used to it, it became second nature.

Well, that really sucks. That's even worse than being crazy. Better to be crazy and talking to yourself than to still be talking to your old girlfriend who's gone. Ugh! Aaron-like. What could be worse? One more reason to hate myself which no one else will understand.

I can see a shadow, a silhouette. Is that Jemuel? Yeah, that's him. But he's not even moving. What is he doing, still working at this hour? Looks like he's taking it hard. Just sitting there at the register, probably listening to sad songs. He must think I'm mad at him. First Susan dumps him, then I get livid when he tells me the details. Well, he should have kept them to himself. It's his own fault. So why is it I want to go comfort him instead of telling him off?

The windows are all fogged up, he can't see me out here. Or maybe he doesn't want to. Maybe I'm the last person he wants to see. I could go tap on the window, but what's the point? What would I say? "You asked for it?" "Now we're both in the same boat?" "Sorry?"

I guess that's a good place to start. If I was sorry. But what should I apologize for? I haven't done anything wrong. Yet.

Thirty

JAIL FORCES YOU TO FACE YOURSELF. It opens up the flood-gates of memory. Already a line had formed in my head, long-asleep voices now stirred and waiting to be heard. I took one look at the line and quickly put on a disguise. Luckily, they were too busy arguing among themselves to spot me as I steered my thoughts elsewhere.

Whew! A narrow escape. In the distance, I could still hear one high voice complain, "He's got a lot of explaining to do when *my* turn comes!"

No, it was better not to look back. Better to just leave the past alone. I wasn't in much of a mood for soul searching anyway. What I really longed for was just to be back home, to wake up and face one more boring, crappy, uneventful day. That sounded like heaven to me. I pictured myself in the kitchen telling Laura the whole story, unburdening my troubles and getting some solace and soothing words in return.

"Laura," I'd confess, "you're not the only one who needs to be held and comforted sometimes, and given a kiss when you get hurt. I need that too."

Then she would cradle me in her arms, holding me as tight as she could. "Poor baby," she'd say.

Yech. Sickening. If it isn't one escape fantasy, it's another.

Sitting in jail and I was just like every other guy, waiting around for some woman to take care of him and mother him and do for him what he couldn't figure out how to do for himself. That was exactly what I *didn't* want to be like. That was why I needed to learn how to take care of myself. Learn how to truly take care of my friends, too. Until I knew how to do that, I couldn't be much of a friend. And until I could solve my own problems, I wasn't ready to be in another relationship.

Another relationship. As if it were that easy. Just find a new girl and move on. Good advice! But what about when you'd already found the one you wanted to be with? When you never had any doubts? When you did everything in your power to court her and keep her, yet one day she decided she'd had enough of you and nothing you did could convince her to stay?

What then?

Of course it took a long time to get over someone. But what if you *never* did?

When you run out of coffee, do you give it up and start drinking water instead? No, you go out and beg and cheat and move mountains to get more coffee. I can give up that girl as easy as I can give up coffee. Some things just can't be replaced. Of course, you drink some water while you wait, to keep from drying up. But it's not the same.

It's not just like I'm idealizing her, either. Putting her on a pedestal. I know she wasn't perfect. Not at all. I remember I'd be lying just like this, trying to sleep. I'd look over and there she'd be on her back, snoring like a fucking manatee, and taking up three quarters of the bed. Her face was all pockmarked, her hair was all over the place, she'd have this crazy look, and I'd be trying to lift her, to move her

over, and it was useless! You'd need a fucking crane! She'd be all sweaty, stinky, drooling maybe, scratching herself, and I'd have to prop my feet against the wall and push with all my might just so I wouldn't get pushed off the bed!

She'd open up one eye and look at me and make this horrible face like I was some kind of war criminal. Still fast asleep, she'd scrunch up her brows and twist her eyes and bare her teeth like a wild animal—and then she'd growl!

And, goddammit. *That* was when I loved her the most of all.

Thirty-one

FROM MY BARRED WINDOW, I watched a new day begin. Finally. I made a little notch in the wall. One more mile marker away from the things we were all trying to forget or return to.

But there was no sense of completion or fulfillment. Everyone lay awake, hoping for some sort of resolution or revelation, some cinematic last-minute reprieve which would save the passing day or at least take out the bad taste it had left in their mouths.

No such luck. Real life wasn't like that. The days didn't even end or begin, they just rolled over. So did we, in our separate corners.

A new day. Besides Jemuel, none of us had any illusions of the rising sun bringing with it a new, fresh start for the world. If anything, each new day just showed the larger holding patterns we were in. There was nothing new. Finding a place for the new piece of the puzzle didn't make the picture any bigger. In fact, it made the picture smaller. It pulled it in closer from all sides. It made you claustrophobic just to think about it.

Go to the record store, go to the bar. Walk the tracks or around town. Try to outrun your problems, or outsmart them, or just sit on the porch or in the driver's seat of a

broken van watching them go by.

Those were the choices, if you could call them choices any more than eating, shitting, and breathing were matters of choice. No, they were just things which had to be done. Chores, habits, duties.

Before heading out on your rounds, don't forget to feed the cats and water the plants, or in Jemuel's case, grandma. Maybe on a lucky day you lost a friend or a lover or got hauled off to jail. Anything to break up the monotony, to make the day memorable, something special. Even then, you probably went to the bar afterwards to clean your wounds and compare notes. To talk out your troubles. To make eyes at the wrong people or watch others make the same mistakes you'd just made.

Or, if you thought you were above that sort of behavior, you made arbitrary rules to set yourself apart. They kept you at home or behind the counter or only at the bar every third Tuesday at three. No matter. The days still added up just the same into another year.

It wasn't that our lives were desolate, only that they were typical, not so different from those in a thousand other small towns and cities across the country. We didn't have the kind of distractions that kept you from seeing how thin and fragile life really is. Everything was stripped down to the bones, without flourishes or pretension. We were all getting a little older, and when you get a little older, you like that. You need less. Less bullshit, especially.

At the same time, it could be embarrassing. What could you say to your old, faraway friends if they wrote or called? It hurt to let on that you sometimes didn't leave the house for days at a time, or that you went to the bar *every* night, or worked your job even when you could have taken the

time off.

What could you do? Nothing but let the letters pile up, leave the phone off the hook, or rot in jail like me, where neither was allowed. Count the minutes and hours until you could get back to your ruts and frustrations, so rudely interrupted, with the people you were already stuck with in the same tank.

Thirty-two

SUNDAY MORNING AND BACK AT THE BANDSHELL. Some things never change, thank goodness. Jemuel's spirits soared taking in the familiar scene. While everyone he knew was fast asleep, he turned off the alarm at the crack of dawn and made his way here. His guilty pleasure, every week.

As he slipped quietly into one of the rows of folding chairs and took a seat, the crowd's attention was torn from the brass band onstage. The chair Jemuel had chosen turned out to be a rickety one, issuing a terrible, ear-piercing set of creaks and moans the moment he sat down. The old faces in every row turned to shoot him the kind of searing, sour looks that take years of practice. They heaped disapproval on him, but it rolled right off. A weirdo he may have been, a Rambo, a moron, a baby, a cock, and, yes, perhaps even a putz. Call him what you will, there was one thing Jemuel was not, and that was self-conscious, luckily. He truly paid no mind to what others thought, or, if he noticed at all, he did not take it to heart. Life was too short for that—and already half over, most likely. Half wasted already.

He looked around the ragtag crowd. Some seniors, some homeless folks whose age it was impossible to tell. Most had a posture and gait which bespoke a common past, but who could be sure? There was also a sense of propriety in

the way they sat there, almost a haughtiness of manner.

Kids, he thought, they just don't take things as seriously today, that's what it is. Everything has to be fun. They don't recognize the gravity of life. Not until it's too late. The funny thing is, a lot of these people aren't even that old. My grandmother would call them kids. "Look at those kids pretending to be all grown up," she'd say. "All dressed up in their fathers' suits and trying to keep a straight face." Even she jokes and teases like she's still a little girl. Or gets frightened for no reason the way little kids do.

The warmth of the sun had a soothing effect on Jemuel. It washed away some of the extra emotion that had been hanging on him lately like a second skin. It smoothed out some of the sharp corners. He felt fresh and new, like when you finally beat a fever and walk out of your house for the first time in a week. It wasn't just the heat—also the feeling of relief that came after Susan's decision. He felt, in retrospect, that everything between them had actually taken a turn for the best. Breakups always give you a strange, delusional sense of hope at first. Jemuel added it to the plentiful supply already in his armory.

"Yesterday's worries belong to yesterday," he told himself. But he didn't really listen or try too hard to be convincing. He tended to pay more attention when it was someone else talking. The little phrases his grandmother used, those always resonated. And Laura, even the things she muttered under her breath took on more significance for him than she would ever realize. How could she? He hadn't responded or even acknowledged the words which had touched him most. To do so would cheapen them somehow.

He loved Susan, but not in that way. It was her being, not her words, which stuck in his mind.

Everyone who wasn't sleeping suddenly made to stand. The band had struck up the national anthem, their final song.

Jemuel stood too.

He thought, I know it's crazy, but I love this part.

A sense of pride swept over him and he blushed.

Thirty-three

THE SUN BEAT DOWN ON DOWNTOWN, illuminating every crack and crevice and showing just how truly shitty and hopeless it was. What a fucking dump! It looked like someone had dropped the bomb. The inky, soulful, restless grid we all loved was a completely different place during the day.

There was a voice among the ruins. "How many lovers have you had?" it asked. "Twenty? Thirty? Fifty? More? You can tell me. I'm not the jealous type."

It was coming from inside the bar.

"Really? That many? How many were girls? Really? How many of them knew what they were doing? Oh, is that so? How many were taller than me? Younger than me? Hotter than me? Oh no, I'm not. No, really, it doesn't matter at all, I'm glad to know. What were they good at? What did they say that I don't? Show me how. Pretend that I'm all of them. One at a time or all put together, it doesn't matter. And how many more will you have after me? The same again? Black? White? Older? Younger? I know you don't know, but just imagine. Now imagine they're all in this body struggling to get out. Yeah, that's right. We're all in here, dying to get out. Help us out. That's right. Rrrrrrr..."

The morning traffic blended with the mincing, mixing sounds until it was all just an unintelligible hum and an

occasional scream. The bells on the record store door were silent, the church bells in full swing. A woman stepped out of the bar and folded back the gate behind her. She picked up the flowers someone had left. "Well, that's settled," she said.

It was Laura. Looked like Laura, smelled like Laura. Too bad, she thought. I was hoping for a more noticeable change. Some scent or mark to bring home and put in the museum. But what did I expect? I won't even get a good story out of this. No, it's bad enough without anyone knowing. Nice work, loser. You really fucked things up this time. Found the sore spot between your last two friends and jumped right in.

Nice spot, though, you've got to admit.

She smiled, wide enough to drool on herself a little bit.

On the steps was a copy of the local paper. She kicked it along as she walked. Used to love reading the news, she remembered. But that was before the war started. Now every issue is a fucking fold-out flag.

She kicked it again and the rubber band snapped. Pieces of newsprint flew everywhere. She looked around. No one in sight. She left the mess and, whistling, turned the corner. A minute later she was back, with a conscience-stricken look on her face, gathering it all up. The sections with the comics and local crap she tossed in a nearby can. The rest she folded under her arm purposefully. With some variation of this routine, she ended up bringing home a copy of the paper every day.

She set the flowers on the tracks.

When I find out who left these for Susan I'm gonna *kill* her. Or him.

Laura walked down her driveway and knocked on the

van. No answer. She lay under the front tires and had a smoke. Should get this thing fixed, she thought. So I can drive it off a cliff. That's more my style. But then where would Aaron live?

Thirty-four

THE BANDSHELL WAS CRADLED between two little hills like a hamlet. You could sense the city nearby, but unless you hiked up the path to one of the hilltops, you couldn't see it. Jemuel considered the view, but decided against going to look—he already knew it by heart. Better to just linger a little in the leftover energy of the concert, not going anywhere.

A maintenance guy in a green jumpsuit came out and lazily started stacking the empty chairs on his cart, wheeling them off to a little bunker to lock them up for another week, mumbling a little tune as he worked. Humming and mumbling at the same time. Humbling.

That's me, Jemuel thought.

But if that's me, then I must be in his way, like everyone at my work. I'd better move.

A little bird walked with Jemuel as he humbled over to a bench. Then another followed. Pigeons. Playing together, they were. Little lovers' games. Courting, flirting. Cute. Jemuel watched, a little jealously. What is it with all these birds, he wondered. He reached back and brushed off his back and his butt, just in case there was birdseed or something there.

After a minute, it became clear the birds weren't going

through mating rituals. The larger bird was messing with the smaller one, and not in a playful way. Jumping on its back, pecking at its beak. The smaller bird was trying to ignore the attack, trying to avoid any confrontation by looking away and pretending nothing was going on—but that only made the larger bird angrier and more insistent. Pretty soon a crowd had gathered, looking on.

Jemuel whistled at the big bird and made motions with his hands, trying to scare it away. The crowd of birds stared at him stonily, their eyes saying, "Stay out of it." Worse, the small bird also stared, but imploringly like, "If you step in to save me, I'll never hear the end of it."

Apparently it was unable to fly, probably the reason it was getting picked on in the first place. Its wings flapped awkwardly, broken. It turned away from the crowd and faced the trunk of a tree, lowering its head and almost comically trying to hide. But the larger bird wouldn't let up.

There was only one bully, like in most crowds. But instead of two or three others teaming up to stop him, or even one stepping in to stand up for the victim, they all just stood back to enjoy the show.

Jemuel felt sick. It was all terrifyingly familiar, as if he'd witnessed the same scene a thousand times. Yet he was still unsure of what to do, unable to make any move at all.

I've played every one of those parts myself, he realized. First the victim, then the bully, then the spectator who can't be bothered to get involved in someone else's worries. Each stage worse than the last. Each step a loss of innocence which makes it harder to go back.

Jemuel stood up suddenly and dove right into the crowd of birds. He chased them in circles, swinging his arms in the air when they stubbornly tried to return. He ran about the

93

park like a madman, waking up one homeless vet and freaking out an Indian family who decided to take their picnic elsewhere. Finally the birds, too, got bored of the game and decided to move on.

The beleaguered little bird was right where they had left it, backed up against the tree. Seeing the coast was clear, it crossed the path and came right underneath the bench, next to Jemuel's feet. It turned its face away, shivering.

"Don't worry, little buddy," Jemuel whispered. But the bird had a look of permanent worry.

Thirty-five

SUSAN STOOD BEHIND THE COUNTER at the bar. The place was empty, not open for another six hours, but she imagined a room full of customers. It was another one of her exercises. Going through the motions helped her think.

She served the imaginary patrons imaginary drinks. Dishwater with a dash of grenadine. Jack Daniels and detergent. "Coming right up," she called, turning around to draw a beer. Discreetly, she held the tap in one hand while she put the other hand under her nose. Ahhh.

She snuck a glance over her shoulder. Everyone was talking amongst themselves. She buried her face in her armpit and took another deep breath. There, too, was the smell of Laura mixed with Susan's own sweat. Even a cold shower couldn't cover that up.

She smiled. Sure, it was bad form to be there in the morning—but this time, what was the rush? It might have been nice to have company for a little while. Where did she have to run off to, anyway? Or who?

Susan cleared the glasses off the counter with a sweep of her arm, then lay herself down in their place. It was one of her favorite games. She spit loogies on the ceiling then tried not to flinch as they slowly dripped down, coming agonizingly close to her face.

She thought, what is that smell? Sweet. But sort of tangy and unpleasant too. One part lilac, one part dogshit, one part gasoline. One part pine trees, one part ocean, one part ice cream.

"What's that? Sorry, didn't hear you. No, we're all out of Old Grandad. Would Old Crow be okay instead?"

Strange. Even with the doors chained shut, customers kept appearing, filling the room to capacity. A storm was on the way, she could tell by the way they dashed in all flustered and out of breath. That was how she felt, too. Rain was good cover. No one even looked up from their drinks. They didn't notice the change.

She held her breath until she turned blue, pounding on the counter with her fists. Then she scratched the air with her feet and dug her nails through the fabric of her pants, making lines on the flesh underneath. She got up and put on a pot of coffee for herself.

Will this *really* change anything, she wondered. Probably not. Will Jemuel and Laura still run around getting ready for the revolution? Will Aaron come pick me up from work? Now he can finally take me home—to Laura's place, that is. From what I hear, it's quite the bachelor pad. Bones and crap all over the place. Sounds kind of creepy. But kind of kinky, too. I bet with a little help, it could be fixed up really nice.

Look at you, already getting big ideas. And you don't even know her last name!

Then again, maybe I'll call up Jemuel and tell him I changed my mind. The day is still young.

Thirty-six

"WHO IS IT?" LAURA ASKED.

"The police."

She opened the door. "I was wondering where you were," she said, rubbing me on the head. "The neighbor kids came over looking for you to skate with."

"Laura, *never* open the door when someone says it's the cops! That's rule number one."

She patted her ass in response.

I followed her into the kitchen. It smelled of bacon grease and cigarettes. Nice. She took out two glasses and half a pitcher of lemonade. We ignored the chairs and sat on the table. How unbelievably good it felt just to stretch my legs and look over at a friend.

"Sing a song with me," I said. "I could really use it right now." I dug out the Subhumans record from the stack on the floor, their angriest, most righteous song ever.

We pointed while we sang. That always helps.

I looked around at the same old punk fliers I'd seen a million times. Still poignant. Laura watched a fat fly buzz around the room. The tonearm scraped at the end of the side. She reached with her toes and lifted it off. No doubt she had been practicing that move for a long time.

I didn't say anything about jail. Why bother and burden

her about it? Besides, it was a small victory just to keep the bad feelings to yourself and refuse to pass them on. Stop the cops from beating two people with one blow. I didn't want to add to Laura's worries, or ruin what seemed like an unusually bright mood.

"This is perfect," I said. "Just sitting around listening to records. Kick your feet up on the table, you know, talk about whatever. You don't have to explain your moods or talk about your day. And if you don't come home some night, what's the big deal? No one has a fit. Why are you making that face? I'm saying it's a *good* thing. That's what's great about being single, you don't have to worry what anyone thinks. You don't have to impress anyone."

Laura looked worried. "What's wrong with impressing someone? You can always impress me. What's the news?"

"I killed two cops last night on my way home from work."

"Wow! That's cool! Good job!" She put both hands over her heart and gazed at me with big eyes. "You're my hero!"

"See, it's not supposed to be quite so easy."

"Hey, I can be hard too." Laura assumed a tough stance, then thought better of it. "But only on myself. So, what happened, the cops take you downtown?"

"Tried to. But I escaped. Hopped out of the car and disappeared amidst a hail of bullets."

"Huh. That's not what I heard. So, why are you such a liar?"

"Every time I tell the truth, no one believes me." I threw my hands up in the air. "So why bother?"

"I have a question. You and Susan ever sleep together?"

"No."

"I see what you mean. Your lies *are* more convincing."

Thirty-seven

OF ALL THE LITTLE LUXURIES I'd set up for myself, the bath was best. A big enamel tub hooked up with water from the house running in two long lengths of garden hose. A wooden cover to keep out the leaves. Even little curtains hanging from PVC pipe. I took my clothes off and got in.

The night's events had exhausted me to the bone. But I was still too tense to sleep. Too wound up. The water was boiling. I stewed in my own juices. Dirtbag soup. Murderous thoughts that had been running through my head started to slow down. Walking now. Calming down.

Laura poked her head out the back door. "Hey," she yelled. "What's it called when you take something, but it's a political act? Starts with an L"

"Loot?"

"No."

"Shoplift? Pickpocket?"

"Aaron, I'm serious."

"And I'm trying to relax!"

"Come on, man."

"Liberate? Reparate? Appropriate?"

"That's the one. Thanks."

I stared up at the gathering clouds, starting to doze a bit. But Laura's voice cut in again.

"Who said that line, *A government that ignores the will of the people loses its mandate to lead*?"

"I don't know. What the hell are you working on in there anyway?"

"Letter to the editor. Want to hear it?"

I nodded, forgetting the curtain between us. "Pull up a chair."

Laura hobbled out of the house with an armful of papers, struggling to keep them all in order while dragging a lawn chair with her other hand. She set up right outside my curtain. Smoke signals rose from her cigarette.

"Just like a confessional," she laughed.

"I wouldn't know. My people do it at the deli. Or on the subway."

"Well, no subway around *here*." Then she sighed. "I remember the subway."

"Laura, just read the letter already. The water's going to get cold."

"Dear Editor," she began. "Wait, do you think its crazy to write letters to the editor? It *is* sort of crazy, isn't it?"

"All sorts of people write letters to the editor."

"I see you're avoiding my questions as always. That's fine."

"Read it!"

She did. It was everything a letter to the editor should be. Sharp, short, opinionated, and sort of nutty. "Wow." I whistled. "That's good. Really good. Pow! But, you'd better not use your real name. That's, like, an instant FBI file. One good trick is, you use someone who's dead. You get a name off a tombstone at the cemetery."

"Good thinking."

"Or a minor figure from history. A second-rate dictator.

Some friends of mine used the old CIA director's name for their phone bill. Free long distance, while it lasted."

"To tell you the truth, I already have a nom de plume. A pretty memorable one."

"Oh, okay. Pardon me."

"Hey, Aaron?"

"Yeah?"

"I've got something to tell you."

I pulled the curtain open and leaned my dripping head over the side of the tub.

"You know, you won't be single forever. So you might as well enjoy it while it lasts. I know you're lonely. No, you let me finish. I've been thinking about this a lot lately. One day some girl is going to show up, and then it's goodbye, Laura, just like that. No more knocking on the door, no more singing together. You'll be making your own music. Don't laugh, it's true. Maybe that bitch who broke your heart will even come crawling back. But I sure hope not. It sucks to see you so miserable, but what can I say? I'm selfish. Cheering you up is one of the only things keeping me alive.

"Now wait right there, I have a surprise."

Thirty-eight

WHAT COULD IT BE? I was dying of curiosity. Laura dashed off with nimble steps, as if the weight of the world had been lifted from her shoulders. She looked different. There was a gleam in her eye which I could've sworn I'd seen somewhere else before.

She came out bearing a huge shopping bag. "Guess what day it is."

I scratched my head. "Thanksgiving? No. May Day? No. Fourth of July? Oh, I know! First of the month!"

"And what does that mean?"

"Crazy day!" we cried together. I cheered. She waved her free hand in the air. "Oh, piss. I think it's starting to rain."

She was right. Droplets fell, then quickly turned into a steady torrent. I was already soaking wet. Laura shook with laughter as the rain ran down her hair and face. The first real rain in a long time. Good for the garden, except it might bring my freshly planted seeds to the surface. Good for the world, anyway. The fucking thing needed a rinse.

"Quit stalling," I said, "and show me what you got."

Laura took each item out of the bag slowly, like a striptease.

"Halva… Tater-tots… Sushi, but it's getting ruined, we'd better eat it fast… Pop-tarts… And finally, ta-da, my token

dyke item: green tea sorbet, with no refined sugar. Just to keep things real."

"Man, life is rough."

"Yup. Hard times. Pass the wasabi."

We sat out there eating despite the downpour, ignoring the rain and the quizzical eyes of a half dozen stray cats watching from the dry safety of my van. Finally I pulled the curtain closed and removed my wet clothes from the line. I wished I had some kind of nautical outfit to change into instead, like a captain's uniform or scuba suit. Getting all dressed up just to stay home was the best.

"Laura," I said. "Are you sure there's not something else? Something worrying you? Some other little surprise you're keeping secret?"

She smiled and kissed me on the cheek. "Goodnight."

As she stepped into her house, I climbed into my van. Goodnight dear friend and neighbor. Step lightly. Go bravely, knowing that I love you.

I put on my leather jacket. I spiked my hair with a bar of soap, using the rear view mirror as a guide. Home sweet home.

"Alright, crew," I told my cats. "Bad weather. Looks like we'll have to cancel the show and camp out here, at least until the roads clear."